CHARLIE, CALLED AND CHOSEN

or

(GOD IN THE INNER CITIES)

My God bless ju

P.

June 2009

CHARLIE, CALLED AND CHOSEN

or

(GOD IN THE INNER CITIES)

First published in the United Kingdom in 2009
by Major Pat Charlesworth

ISBN 978-0-9561471-0-3

Produced by
The Choir Press
www.thechoirpress.co.uk

Contents

Glossary

Corps or Citadel:
: Salvation Army Centre for worship and associated services.

Goodwill Officer:
: A Salvation Army Officer specifically trained for inner city work in the community.

Goodwill Centre:
: A Salvation Army Centre for worship and community work within the inner city, usually amongst poor needy and disadvantaged people.

Officer:
: Commissioned and ordained minister practising in the ceremonies and doctrines of The Salvation Army.

Mercy Seat:
: Focal point in any Salvation Army Centre for the purpose of any affirmation of faith and commitment.

Appeal:
: In the tradition of The Salvation Army, an evangelical invitation to service or commitment.

Covenant: All Salvation Army Officers sign a covenant with God before they are commissioned

Soldiers: Rank and file members of The Salvation Army.

Home League: A fellowship hour of education and worship ending with a cup of tea.

Adherent: Person wishing to be linked as a member of The Salvation Army without the commitment of soldiership

Chapter One

My older brother, Ian, was born during the Second World War. Our dad, like his father had been in the First World War, was fighting away from home. Our grandfather was killed in 1915 and so our dad never knew him. With this at the forefront of his mind Dad wrote to Ian saying that, should he return home, he promised he would make him a wooden train. He added that there was a secret too. He would make the train big enough for a baby sister! Well, thankfully Dad did come home safely from the conflicts and in time I was born and christened Patricia Ann.

Our dad was a mechanic and Mum worked in a radio and television repair shop. Life was hard. It was not easy to make ends meet but somehow they did manage and we were spared many of the difficulties they must have experienced. Our home was a rented terrace house in Scunthorpe. There was an outside toilet and no running hot water, so we were glad to visit our maternal grandma for a bath every Friday night. Nanna Vessey was a devout Methodist, so we went to the Methodist Sunday School. Our great uncle was a Salvationist and he

invited mum and dad to a Harvest Festival meeting
at the local Salvation Army corps. They both began
to attend regularly and became Christians, Mum
taking on the commitment of soldiership. We trans-
ferred to The Salvation Army Sunday School and
soon were part of the 'army family'. Our mum and
dad were really involved, especially during the 1953
floods on the east coast where they helped with
rescue work and, of course, gave out the proverbial
'Army cup of tea.'

At the age of eight, Ian joined the Army Junior
Brass Band. When it came to my turn to join they
had no spare instruments to loan, but I was given
the fingering of the C scale to learn. I thought there
was no better way to learn than to use the E flat
bass (tuba) loaned to my brother. I was so proud on
going to the learners' practice the following week,
because I could play the C scale on the bass. We
shared the instrument for a while until a battered
brass bass was found for me. As I was so slim in
those days I earned the nickname 'flat Pat'. I was
often told I was the only girl who could hula-hoop
with a 'Polo' mint!

Junior school was difficult and as we both went
to the same school I was always known as
'Charlie's' kid sister. This came about, as our family
name was Charlesworth. Eventually, when Ian left
for senior school I was simply known as Charlie.

One Sunday, when I was thirteen years of age, I
was singing the words of the song 'How great Thou
art' in the morning service

'And when I think that God His Son not sparing,
Sent Him to die – I scarce can take it in.
That on the cross my burden gladly bearing,
He bled and died to take away my sin.'

God came into my life on that day and I became a Christian. That was just the beginning; there was so much more He had to show and give me.

I was thrilled to pass my eleven plus examination and went to a new grammar school. There was a new experiment where it was made possible for the top class to take the GCE examinations in four instead of five years. Everyone in the class was expected to pass sufficient exams to progress to the sixth form a year early. I was one of two people who failed miserably – only passing the maths exam, which I considered was my weakest subject. I had the choice to go into the top class of the fourth year or go into the second class in the fifth year. I chose to stay in the fourth year and at first life was very difficult because I knew nobody in the class. However, as the year progressed I became an active member of the debating society and played in the school hockey team. I really developed my leadership skills, which I did not think I had, during this time. The second time around I managed to pass sufficient exams to go on to the sixth form but, despite the headmaster's coercion when he said that I would get nowhere if I did not join the sixth form, I applied for a job at the local steelworks. A job in the Hollerith Department was offered me because I had passed my Maths G.C.E. a year earlier! I took

the job and found that amongst the employees was a friend from junior school who naturally called me Charlie. I suppose it was as well because there were four Pats in the office! God was certainly in it all, especially as during the four years I spent there four people became Christians.

In my home town of Scunthorpe, on the first Sunday of 1963, whilst attending a meeting at the Citadel, after months of inner conviction that God was calling me to be a Salvation Army Officer, I knelt at the Mercy Seat, emblazoned with the words: – PARDON, PEACE, POWER. The congregation were singing the song 'How can I better serve Thee, Lord?' and that was my prayer. I said to God "If that's what You want me to do I'll do it, but God, You're really going to have to show me, because I'm not sure it's right." On May 17th of that same year I had the opportunity to go to the commissioning of the cadets for officership at the Royal Albert Hall. I felt it was going to be a significant day one way or another. Seating in the Albert Hall is in multi-tiers, almost up to the roof, where the top-most ones are fondly called 'the gods' and I was seated there for the evening meeting. This meant negotiating many stairs and doors, a proverbial warren. "Well, that's it," I thought, " I'll never find my way down to the platform when the appeal comes!" (In my naive way I felt that going to the platform was the only way I could offer my life for officership.) However, when the appeal came, I got up and remember nothing more until I was on the ground floor facing numerous doors. I was so timid,

I began to waiver, not realising that all doors led to the Auditorium. Amazingly, although it was the middle of the prayer meeting, someone came up to me and asked if I needed help and took me to the platform. To this day I don't know who that person was, but to me she was an angel. So you see, thankfully God really did show me a way in answer to my prayer and so the process began.

Sundays became increasingly busy at Scunthorpe Citadel: morning Sunday School, Holiness Meeting, afternoon Sunday School, Praise Meeting, Open Air Meeting, Salvation Meeting. I had begun to collect children from around the district for the afternoon Sunday School. This entailed a hasty lunch following the morning meeting, calling first of all at one home, where I washed and dressed two youngsters (their mother liked to sleep in and their father was in prison.) These youngsters were soon joined by many more and Pat and her 'children' became a familiar sight on the High Street.

This continuing confirmation of my calling gave me an assurance and certainty in the power and love of God that I'd never known before Although there have been many spiritual ups and downs since then, I know that on May 17th 1963 a power was released into my life which has never left me. I am so grateful for my family and friends who supported me through these formative years. I knew I was to be a Salvation Army Officer. I didn't know how God was going to do it but I knew somehow He would.

Eventually I arrived at the 'Army's' International

Training College for officers, in Denmark Hill, London, as a member of 'The Evangelists' session. During these two years I didn't take to communal living easily but benefited from the care and training given me. During my practical training, I had the privilege of attending Deptford Goodwill Centre run by Major Annie McClennan. Listening to her stories of how God had used her to help those less fortunate, I began to feel a stirring in my heart to offer myself to be a Goodwill Officer. This was in my mind as I filled in the obligatory form stating which line of work within the Salvation Army I felt called to. I put a cross against Goodwill work with a p.s. saying I had a leaning towards this work but as yet it wasn't a call. Didn't I make life difficult?

Through visits to other Goodwill Centres including Bethnal Green under the leadership of Brigadier Eleanor Gebbie, this conviction increased. The day came for the college interviews to tell us for which work we had been selected. Imagine my joy when Colonel Jean Trainer, Chief Women's Officer shared how glad she was when I'd expressed my convictions, for that was where her staff prayerfully felt I belonged as I had a big heart!

My second year of training confirmed that indeed I was in the right calling and soon it was Covenant Day. Songs have played a significant part in my spiritual life and none more so than 'In heavenly love abiding' (*SASB 736*). It was during the singing of the words 'He knows the way He taketh and I will walk with Him' that I signed my covenant endorsing that the following vows:

'Called by God to proclaim the Gospel of our Lord and Saviour Jesus

Christ as an officer in the Salvation Army I bind myself to Him in this solemn covenant:

> To love and serve Him supremely all my days.
>
> To live to win souls and make their salvation the first purpose of my life.
>
> To maintain the doctrines and principles of The Salvation Army, and, by God's grace, to prove myself a worthy officer.

Done in the strength of my dear Saviour and in the presence of the Chief of Staff, Training College officers and comrade cadets.

What joy I found on Commissioning Day, 23rd May 1969, at the spot where I had stood years before in The Royal Albert Hall, now to receive my first appointment – to be assistant officer to Captain Dorothy Cook (Dot) at Leeds Meanwood Goodwill Centre.

Chapter Two

Arriving in Leeds to take up our appointment, we discovered our temporary quarters was in Spring View Rise. A member of the Training College Staff wrote saying how idyllic it sounded. It might have sounded idyllic but it was a two-up two-down back-to-back house with a view of the local gasometers! To reach the Goodwill Centre we had to catch two buses, one into the city and one out to Meanwood; this became quite interesting if we missed the connections!

Leeds Meanwood had been a corps but its designation was changed to a Goodwill Centre. There was a nucleus of people who had been faithful through the years but they found it difficult to adapt to what they saw as a demotion to a Goodwill Centre. Happily, they soon realised that it wasn't a demotion as they had two hard-working officers who cared for them as God's people and also cared for those in the community.

After some months, we finally acquired a council flat in a tower block, quite near to the Centre. It was lovely having a decent view from the ninth floor and a joy not to have to go out the front door

to visit the toilet or hang the washing in the front garden!

During the time when we were sorting out the new flat, we had occasion to travel to Otley in a car loaned to us by Bandmaster Walter Crabtree of Leeds Hunslet Corps. He had been very helpful to us as he worked in the Army's salvage department and supplied us with lots of good furniture. Our journey to Otley was on a beautiful, crisp, sunny November morning. Dot had been trying to persuade me to learn to drive but I wasn't so sure it was a good idea. However on this journey I remarked, "It's on a morning like this I wish I could learn to drive." Later that day Dot disappeared. She returned with an application for a driving licence and the news that she had booked me in for driving lessons! This might seem like a trivial incident, but had it not been for Dot, I still might never have learnt to drive and so much would have been missed in work and pleasure.

Whilst living in the flat we used to have many conversations with other residents, as we travelled in the lift. In conversation with a middle-aged gentleman, he told us how difficult it was to clean his windows, so I offered to clean them for him once a fortnight. He always made me a cup of tea and we had many a good chat, as he was very lonely. All went well until one day he inquired if our flat was like his. I replied "Yes, it was; however we had lots of pictures and ornaments which made it more homely." He then asked the mind-blowing question, "Well, if I was to ask you to marry me and

come and live here, you might change a few things!" I certainly changed one thing! I linked him up with a widow in the neighbourhood who then went to clean his windows! I wonder if they ever got married? Life would certainly have been very different if I'd said yes!

Having inherited the old corps history books, we began to look at names and addresses on the soldiers' roll and discovered the names of a number of folk who no longer attended the Army. Most of them had moved away, except for one couple who lived two streets away from the Centre. After lots of prayerful visits, what a thrill it was when they both came back to God, renewed their commitments to Him and the Army and shared fellowship in the meetings.

We were blessed with good caring people around us – none more so than the local garage Appleyards. They agreed to loan us a car for a year, free of charge. It was a little mini-traveller, which was just as well, because I was learning to drive in a mini car. They paid all the tax and insurance for the year then replaced it with another the following year. I never cease to be amazed at the kindness and generosity of business people, who when they become aware of the work being done by The Salvation Army, kindly assist in many practical ways.

As we worked and visited in the area, we became aware of the loneliness of the elderly folk who were living within a re-development area. There was a great need for them to meet together and the best

way— a Luncheon Club. So we started one, despite neither of us knowing much about cooking – not even Dot with the surname Cook! It was good to see the folk come to the hall and finding warmth and fellowship. Soon some began to attend the meetings and found God as their personal Saviour and Friend.

On Christmas Day we realised many of the folk would be on their own, as families had moved away or partners had died. With much trepidation, we announced we would cook a Christmas Dinner! Thankfully the chef from the local Salvation Army Hostel cooked and carved the turkeys for us but we managed the rest.

After a while, children from the Sunday School started attending the meetings and expressed the desire to become Christians. There were no Junior Soldier activity books in those days so painstakingly we typed out, with carbon copies, a week by week explanation of the Junior Soldier Promise and what it meant to be a Christian. What a thrill to enrol some of young people as Junior Soldiers and then form a little singing group. Some of the parents came to the meeting when they were enrolled and continued to attend the Sunday meetings. Many of those children will be grandparents now. It would be good to know if they remember something of what they learnt in their formative years.

Remember Walter, the Bandmaster? Eventually, as he was a widower, he proposed to Dot and she accepted. The following year they were married. This meant a tremendous change, as I stayed on at

the Centre and another officer came as my commanding officer. One of the services we then developed was helping the WRVS to deliver meals on one day of the week. This took us into many homes where we were able to share their sorrows and their joys as well as take the people a meal.

In the meantime the Sunday School grew and grew until there wasn't enough room for them all in the hall. We borrowed the use of a room from the Methodist Church next door and there I ran the primary class. It was like being back home — 'Pat with her children!'

A new challenge presented itself when Brigadier Eileen Luckham from Goodwill Headquarters visited us and asked me if I would be willing to go to Plymouth to commence a new work.

Chapter Three

On arrival in Plymouth, the remit was to introduce community work in each of the four Corps within the Plymouth area. Devonport Moricetown already had an established workshop and luncheon club for the elderly and handicapped. Members of the Rotary Club of Plymouth brought the folk into the hall each Thursday. This was quite an experience for some of them as they were brought to the hall in top class cars, including a Rolls Royce. In the morning they worked at making trays and various other handicrafts. They were then given a cooked lunch followed by a short service after which they were taken home. For many of them, who lived alone, it was the highlight of their week.

One of the drivers was a very wealthy gentleman with his own business and a beautiful home in Dartmoor National Park. On his invitation I went to his home for coffee. There I found, despite his wealth and success, a very sad and lonely gentleman who was grieving for the loss of his wife who had died three years previously. What a lesson I learnt on that day! At that time, my experience in working with people, who in the eyes of society

were wealthy, was limited, but there I learnt that it is not just the poor who are in need of care and of God, but the affluent too are affected by grief and sadness and they also need God.

Not long after arriving in Plymouth, airmen stationed at RAF Mountbatten gave The Salvation Army a brand new vehicle, the only proviso being that their name and logo would be detailed on the van. It was a very useful asset as all the corps had to be regularly visited so relationships would be built up and needs assessed according to each of the different areas.

After a period of time, our leaders asked me if I would accept Lieutenant Norma Richardson to live and work with me. I was told she had been through a difficult early phase of her vocation and needed to be treated kindly. On meeting her at the railway station she was very quiet. I did not want to hurt her so by the end of the day I explained I was a slow starter in the morning and probably would not speak to her for an hour. I reassured her that this was nothing she had said or done but was just my slow process of waking. She assured me she was quiet in a morning, so that was good. Well, it was for the first morning but on the second morning, and ever after that, she would sing at the top of her voice whilst in the bathroom! On the same day, after visiting someone we, called into the local shoe shop, as I needed new shoes. Being very self-conscious of the size of my shoe, I whispered to the shop assistant that I needed a size eight. For

some reason, on hearing this Norma guffawed with laughter and went out of the shop saying she had never heard of anyone taking such a big shoe size! Despite this rocky start we soon found that we were a team, for what I couldn't do she could and vice-versa.

We began to visit a home for the elderly in one of the corps' areas and took some teenagers from the corps to help. With regular visits we soon got to know the folk and their visitors. One couple had been married for fifty years and the husband visited his wife daily, cycling two miles to see her. He was always there for 1p.m. and never missed. Imagine the consternation when he didn't turn up on one occasion. To allay his wife's fears, Norma and I promised to go and look for him at his home. When we arrived at the house the bicycle was still there, leaning up against the wall. We knocked loudly at both doors but to no avail. There was only one thing for it – one of us needed to climb through an open window and see if he was inside. Norma, being younger and more agile, went in and then opened the door for me. We gingerly went through each room fully expecting to see the husband ill or at the worst dead. However we found no one. We decided to go back to the home and explain the situation to the staff of the hospital, but on arrival whom did we see, but the husband very much alive! Apparently someone had called on him at home and delayed him so much that he thought, in order not to agitate his wife by being late, he would get a taxi! We never divulged our adventure and were glad no

one had reported us breaking in, especially as we were in full Salvation Army uniforms!

We began to visit a lady regularly and soon found out that her deepest sorrow was that she could no longer read her bible, as she was going blind. We devised a rota of young teenagers from the local corps so that every day someone would go to read the Bible to her. We coordinated this in order to avoid a diet of Psalm 23 everyday!

On one occasion, we received a letter from a lady in Scotland who was trying to trace her grandma to whom she had written at her last known address in Plymouth. She had had no reply and was very concerned. We went to that address and asked around the neighbours if they knew the whereabouts of grandma. She had moved to a road in another part of Plymouth, but unfortunately they didn't know the number of the house. With some of the teenagers we began to knock on every door in this road, asking for grandma by name. At last we found her! Well, that's not quite true. We found where she *had* lived but she had moved again into a residential home in another area of Plymouth. We asked the name of the home. Unknown! By now, feeling like detectives, we telephoned numerous homes in the stated area, asking for grandma and finally we found her. We went to visit her and there she was, a delightful ninety-year-old filling in her football coupons! We laughed with her but soon found out that she filled in the football coupons just to ensure she would have some mail like the other residents. There is a happy ending to this story

because, on notifying the granddaughter of her grandma's whereabouts, she wrote to her sending photographs of her great grandchildren. How proud she was to show these to us and to receive regular letters. We don't know if she still filled in the football coupons or even if she won anything, but she was certainly a happy lady who felt loved and needed again.

One of the corps halls was right in the city centre and so with lots of help from the soldiers and friends there, we established a well-attended coffee morning. It was good to see people coming into the hall and building relationships with Christians there. Many links were made by this outreach and some folk began to attend the meetings and became Christians.

At yet another corps, there was a real need in the area for a mums and tots group, so with the soldiers and friends we opened a charity shop to raise money for equipment. We had raised £1000 when out of the blue came a letter notifying us that we were moving to Bristol. We're glad to say the corps still went ahead with the project. So it seemed as if our work for God in Plymouth was done and the remit completed.

Chapter Four

Our directives for Bristol were to work in the community with the corps officers and soldiers of Bristol Citadel, whilst maintaining community work at an old corps hall in Bristol Filton.

Moving in November meant we were thrown right into the Christmas programme, which involved distribution of toys to needy families in the area. The public had generously donated many toys so our job was to sort them out and allocate them to the appropriate families. This went really well until it suddenly dawned on us that the board game 'Cops and Robbers' was not really suitable for a family whose dad was in prison!

On Christmas day, along with officers, soldiers and friends of Bristol Citadel, we organised a meal for two hundred lonely and elderly people. As Norma was a very good cook, the first year went really well. However, on our second year, following the procedure of the previous year, we unfortunately ran out of turkey before everyone was fed. Some of the soldiers went home and commandeered their own turkeys being cooked by their wives and so, thankfully, no one but the kitchen staff knew

what had happened and all went home well fed and happy!

When we arrived in Bristol we had 'inherited' an A40 van which was far past its best.

The door would fly open as we turned a corner. It would jump out of second gear and it was not unknown to get wet when it rained! A point I was to remember well. I had been asked to speak at a meeting of the Women's Institute. Having my best uniform on and being spick and span, I thought it would be a good idea to arrive with a clean van, so off I went to the local car wash. Yes, the water came at me from all sides! I had to go back home and get my second best uniform on and dry my hair!

Thankfully, as part of the television programme Blue Peter, which held its appeal in 1972, we were given a brand new Blue Peter Hot Dinner Van. We even had the crew, including Peter Purves, come and film us cooking and distributing the hot dinners. Needless to say, by the time the film crew had managed to film everything it was a very cold dinner, no matter what the recipient said on the film!

Bristol Filton Corps had closed so every Sunday we took an elderly lady, who had been a soldier there, to Bristol Citadel. Often she would offer us money for taking her but we never took it as we were attending the meeting anyway. God taught me a great lesson through this lady. On one very rare occasion I had to fill the van up with petrol and again she offered me money, which I refused. Whilst I was paying for the petrol the lady started to cry

and asked Norma why she could not, occasionally, show how grateful she was to receive a lift. The lesson? To remember that sometimes we have to learn to receive as well as give.

There was another lady, who had been a soldier at Filton, but somehow she had been missed out in the transfers and no one knew about her. Fortunately whilst visiting someone else we became aware of her circumstances and as it was nearing Easter-time we asked Bristol Citadel Senior Band if they would play some music outside her home. This they willingly did to the great joy of the lady. Not long afterwards she died but her daughter said 'I am so glad that you have come to Bristol so that my mum knew The Army did still care.' This comment helped us tremendously as we both felt the appointment to Bristol had not the same ring of guidance as other appointments. It may have been a man-made appointment but it had not stopped God from using us there.

The two areas we worked in were very different, which was very apparent in the two playgroups we ran. The Bristol Citadel playgroup was a multi-racial group; one child named Giaho-Franco-Moto was called Jon for easiness!

The Filton children were from mainly English families; many of the children had only one parent. It was good to see the children develop over the years as they played and learnt new skills in the warm and friendly atmosphere of the Centres.

One of the highlights of my week was to continue our predecessor's work by visiting Helen, a severely

mentally handicapped six year-old child. Her parents had taken her to an institute in Philadelphia, America, where Helen was put on a daily regime to try and stimulate the part of the brain that was not damaged. This meant a 'round the clock' exercise regime including crawling, twisting arms and legs, and climbing amidst general encouragement of her and, of course, her parents. Her parents and family and friends had a daily rota and it was my privilege to share the programme with her every Friday morning. In order to encourage her to crawl (she couldn't walk), I used to be the one to crawl with her whilst reciting nursery rhymes. What a thrill when one Friday she said her first word ... sheep. Over the two and a half years sharing the responsibilities of these exercises with the family it was a real thrill to see the programme work. Helen's parents and family deserved a medal for their unstinting efforts to help Helen, who continued to progress slowly but surely. A few years later I went back to see the family and there was Helen walking and conducting a conversation with me. It was truly a miracle.

During our appointment in Bristol, I personally felt very unfulfilled as a Salvation Army Officer, with little outlet for conducting meetings and no opportunity to teach and train new Christians. My officer's covenant was ' to live to win souls and make their salvation the first purpose of my life'. I didn't feel I was doing this and thought I would be just as useful to God in secular employment. Unknown to anyone but Norma, I had been offered

a job and felt that, after fulfilling my Christmas duties (Christmas Day meal for 200 and Boxing Day party for children) I would offer my resignation. However, God had other ideas because a month before Christmas we were asked by our leaders if we would be willing to go to work in Belfast, Northern Ireland. God so clearly slammed one door closed and opened another. So, not knowing what to expect, we agreed to go to Belfast in January 1975, my covenant renewed and my relationship with God much stronger.

Chapter Five

On January 14th 1975 we arrived at Belfast Airport to be met by the local corps officers. They took us to their home for tea and eventually took us to our quarters in Thistle Street. (We found out later that they waited to take us round there until it was dark and we couldn't see how awful it was.)

The quarters was a two up two down small terrace house with a bathroom off the kitchen. At the corner of our street was the security checkpoint between the Republicans (Roman Catholics) and Loyalists (Protestants). On going to bed that night we were really frightened because we could hear talking in the street below. With relief we soon realised it was the British Army soldiers patrolling the area as they did every night until midnight.

The next day we visited our Goodwill Centre. We discovered it was in the middle of a redevelopment area and had no running water. Electrical fuses that were outside the building had to be removed every time we were not using the building, otherwise they would be stolen!

There were a few faithful people attending the Centre, along with a few children and a small group

of teenagers. The hall had been a darts' hall and so had green benches down each side, a dirty stone floor and dark cream walls and ceiling. We, along with the teenagers, decided to paint the hall and so on July 12th (a bank holiday in Belfast) we painted the walls and ceiling white, the benches navy blue and the floor cardinal red – quite significant, although not planned, as they were the British colours!

Not long after our arrival in Belfast we had the opportunity, with the help of the West London Division of The Salvation Army, to take 12 children on holiday to England. What an experience for them as they arrived at the hall with what clothes they had in plastic carrier bags! At first they were over-awed by the size of the aeroplane taking them to London but they soon lost their awe and found they could press buttons and call for anything they wished – interesting but exhausting for the two of us trying to keep control. However the air stewardesses were so calm and helpful, recognising this was the first time the children had been out of Belfast, never mind on a plane.

The children had a lovely holiday. They were taken to a local stable. At first they were quite unsure of the horses, but once one had had the courage to ride the horse, they were all eager for their turn. They looked so proud on the horses with all the equipment and were excited to tell their friends that they had ridden, not a donkey but a real horse! A visit to a turkey farm was absolutely amazing, especially as most of the children had only ever seen a turkey in the freezer at the shops. Some-

thing else they would never forget was going to a garden party in a garden bigger than all their homes put together. The lady of the mansion was so thrilled to see the children playing in the grounds that when it started to rain she invited the youngsters into her conservatory and suggested they use the highly polished table and cut crystal glasses for their lunch. Fortunately we had brought paper cups and serviettes, so no damage was done. This was a truly memorable holiday and the children shared their experiences with their parents for many a week.

We soon linked up with the local Corps in Belfast and found the officers and soldiers very helpful. We borrowed a local community hall with a kitchen and established a workshop and Luncheon Club for the elderly; similar to the one we had run in Plymouth. Soon many elderly people were referred to us. Some of the soldiers of the corps and centre folk helped with the meals and we had a lovely lady, who was an expert in craftwork, who came and taught the folk. I remember one lady in tears because she had had a stroke and lost the use of her right hand. She was bitterly disappointed because she had enjoyed doing tapestry. Over the weeks and months she was taught to weave baskets and trays with her left hand. One day she came in, so proud, because she had sewn some tapestry with her left hand. The joy on her face was such a reward to all involved, who had painstakingly supported her through the year.

When it came to the first Christmas we knew we

couldn't use our centre, or the community centre we were using each week. But we wanted to provide a lunch for those who would be on their own on Christmas Day. So, small though it was, we invited eight people to share our home that day. Two people declined to come, so we offered to take a meal round to their homes. I went with the cooked meal to the first lady to find she had forgotten it was Christmas Day and she hadn't even opened her present. I was reduced to tears as I thought of the lovely time we had had the previous evening as we had opened our presents. Norma, meanwhile, went off with the other meal. The gentleman had forgotten she was coming and had made a bowl of porridge for his Christmas dinner. Needless to say, we both shed tears again! However, when the folk came, we had a lovely day celebrating Christ's birth. This was really a day never to be forgotten by anyone involved.

During that first year, we were approached by the national leader of the Salvation Army and asked if we saw a future for the work in the area. We both agreed that there was, especially as The Salvation Army had already been allocated a plot in the new development area. The problem, of course, was money. We, and the folk at the Centre made this a matter of daily prayer. We had a charity shop for a month and were assisted by local secondary school girls. We sent out an appeal for Green Shield stamps for equipment. One of the children came and gave us her pocket money – 5p that moved others to give also. We drew a diagram of a hall and asked people

to work towards filling each brick in, which would be the equivalent of raising £100 but after much hard work we managed to raise £1000 – but even that was just a drop in the ocean for a new building.

The hopes of help from contacts in the USA fell through but the International Headquarters Public Relations Department took on the cause and made a film –'Strife-Torn City'. This certainly helped, but we were still a long way off the amount needed.

In faith, plans were drawn up and were to include a main hall, an equipped kitchen and lounge as well as living accommodation above and an emergency flatlet complete with shower. Extravagant plans when we had so little money!

However God deals with extravagant plans and He did this time. People in the community were beginning to know all that God was doing through us and supported well. Meanwhile the British Government decided to give financial grants to five Belfast areas of great need and invited applications. The stipulations were that it would be a new building with plans submitted, within the areas allocated, wanted by the community and for the community. It was all very official and I had to go to present our cause to Stormont (The Northern Ireland Houses of Parliament). The 'youngster' from Scunthorpe was very over-awed, but God gave me a calmness and positiveness that won the day and we were given £150,000 grant to build the new centre. What an amazing God!

The very same week that we heard the news of

the grant, we had been visiting an elderly lady and her daughter. They were living in appalling conditions. The mother, although ill, was laid on a settee covered by an old coat. We suggested to the daughter that mum would be better upstairs in bed. The daughter told us neither of them could sleep upstairs as water was running down the walls. Perhaps, then, blankets would be more appropriate for her. No, there were no blankets because they had all got mildew.

Norma stayed with the ladies whilst I went back to the quarters where we had plenty of blankets on the beds. I took some off the beds and I remember saying "Well, Lord, I'm going to get into trouble for giving away Salvation Army property, but I can't see the lady living through another night like she is." Returning to the house we managed to get her comfortable with hot water bottles and coal on the fire. We left them both reasonably comfortable, promising to return the next day. We soon arranged for them to be re-housed in the new re-development area. The wonderful thing about this experience was that the very next morning we received a telephone call from someone wishing to give some blankets to the Salvation Army. On collection, we found them to be better than the ones I had given away! Our God is such a great and faithful God, who meets all our need, whether it is £150,000 or five blankets.

Whilst living in Thistle Street we did experience quite a lot of 'the troubles', as the constant warfare was known. Often we had to go out of the house via

the back door because bricks were being thrown up and down the street. On one occasion our telephone was cut off because the telegraph pole had been set alight. We had to endure this for quite a number of weeks because we were told the engineers refused to work in such a dangerous area!

Always we had the protection of God, through our many prayer supporters. None more so than when on one occasion we had gone to share the evening with friends and didn't return home until 1.30am (a rare occasion for us to be out so late). My first reaction was to query why The Military were still patrolling the street at that time. When we turned into the street we saw that Council workers were boarding up the windows of our house. Apparently youths had come round and thrown bricks through all the windows at 1.15am When we went upstairs there was a brick the size of a hand on Norma's pillow in the front bedroom. This would have possibly been fatal for her if we had been home, but God had protected us, for which we praised Him. A kind couple from one of the local corps let us stay with them until we had the windows replaced. On hearing of our predicament the Roman Catholic Father came to visit us with a letter of apology from the perpetrators.

On one occasion the Priest's car had broken down and he had promised to take a Roman Catholic family down the coast for a holiday. I used the Salvation Army car and took the lady and three children to their holiday. In conversation the lady said she knew no Protestants at all. "But, I'm a

Protestant," I replied. Her answer was "Ah well, you're different, you're Salvation Army."

On another occasion a little boy was knocked down in a traffic accident just inside the Roman Catholic area. Our neighbour, a staunch Protestant, came to tell us and asked if we would go and find out how he was because she knew we could go freely in both areas.

These incidents show the esteem both sides of the border had for the work of The Salvation Army and it was a real privilege to carry on this work.

Norma was away for a week, on a Salvation Army course, and because I was trying to do the work of two people I was very tired. This particular night, at 10pm I began to prepare for bed when there was a knock on the door. It was a lady I knew. She had come to ask if I had any spare beds. The story unfolded that her daughter and husband, both alcoholics, had argued and brought out a knife in front of their four children. The granddaughter, aged twelve, went for Grandma who called in the police and the parents were taken to the police station. Grandma said rather than the children being taken to various homes, she would look after them at her home. So, she had come to the Salvation Army for help. Fortunately, someone had loaned us two sets of bunk beds as we had had visitors at the weekend. It didn't take us long to get the beds in the van and off to Grandma's home. We put up the beds and I took time to listen to the children and calm them down before they went to sleep. Arriving home at approximately 2.30am I was very, very

tired and remember saying out loud "Well, God, is this what you called me to do, shift beds?" I got my answer on the following Sunday when all four children came to Sunday School and eventually they all became Christians and junior members of The Salvation Army. Grandma too started to attend the meetings regularly.

Some time later we moved into a beautiful, furnished quarters built above an even more beautiful hall and purpose-built kitchen, and an emergency accommodation flat; but the work commenced in the wooden hut and the loaned community centre continued. We extended the workshops and meals to two days a week and new people started to come into the Centre. We kept a photograph of the old hut, in the foyer, to remind all from what God had brought us and that which He had now given us.

The emergency flat was used frequently by mums and children caught up in domestic violence who would stay for a maximum of two days to give the authorities time to find them somewhere more permanent to live.

We had one gentleman come to us, through Social Services. He lived in a dirty, untidy home and had been refused entry into all Day Centres because he was so dirty. We accepted him at the Army and every week we would provide him with clean clothes, which he put on after a shower in the emergency flatlet. This meant that the other groups accepted him when we were not available.

Then, there was John. He was an alcoholic and

many a time we had to go and fetch him out of the pubs or 'speak-easys' and take him home. Sometimes under the influence of drink, often with a bottle of drink in his pocket, he would arrive at the quarters with deep remorse, wishing he could be free of this addiction. Whilst he was talking to me, Norma would sit beside him and gradually take the bottle of alcohol out of his pocket, so he couldn't have any more. We prayed so often that the addiction would be broken and John, himself often went to the Mercy Seat in the meetings to ask God for help to stop him from drinking, but it seemed to no avail. One Sunday, he again knelt at the Mercy Seat and asked God for help. Oh, how we prayed that this time it would happen! The next morning, whilst I was engaged in the clerical work of the Centre, John came to the door. There he was in his paint-spattered overalls and said " I've just come in the cold light of Monday morning to kneel again at the Mercy Seat, for I really do want God to take over my life." So we went to the Mercy Seat and John committed his whole life to God. God did take over and despite a tortuous journey through his life and that of Eileen, his wife; they became officers in The Salvation Army. What a privilege it was to meet them again at Swanwick Officers Councils 2005. But that wasn't all, for they introduced me to five other officers who had answered the call for officership through their ministry. It made all those long hours worth it. God is so great and He does far more than we can ever think or dare to imagine.

After five and a half years in Belfast it was time to

move to a new appointment and so as we got on the plane, with much more awareness of what God can do, we headed for Bethnal Green in London.

Chapter Six

Norma and I arrived at Bethnal Green as the builders moved in to renovate both the hall and quarters above. This meant we had to live in empty officers' quarters, five miles away. This was not the best start to an appointment, but with God's grace we survived, even though The Salvation Army van we used was stolen! Despite the workmen using both halls we managed to keep the services going, even though we had to dust before every service and inter-change halls at a moments notice!

At the Centre we found good Brownie and Guide Packs, which was difficult as neither of us had ever been responsible for that type of work and there were no other leaders. We often did things wrong but soon picked it up as we studied the manuals and eventually we were warranted and still both packs prospered with good numbers attending.

On November 26th 1980 we moved into our newly decorated quarters above the hall.

It was interesting as the main-line trains going east were literally at the side of the premises, so close that in the bedroom upstairs we could have shaken hands with the passengers as the train

passed by. How we thanked God for double-glazing!

Two days later, my father unexpectedly died and so I needed to get home as quickly as possible by train. We hadn't any savings as we had used most of them during the past five and a half years, travelling back and forwards from Belfast, visiting my parents,. I had to borrow £40 for my train fare, which was quite a sum of money on our limited allowance. Over the week-end our national leader contacted Norma and said that if she could get all the activities at the Centre covered she had permission to join me at Scunthorpe, especially as my parents treated Norma like a daughter because her own parents were dead.

When Norma phoned with this news, pleased though I was, it just was not possible to go into debt with another £40. Norma never told anyone of our predicament, except God. On the Monday morning pushed through the letterbox was an envelope containing £80 and two Mars Bars! What an answer to prayer and another lesson learnt of God's provision. To this day I don't know who the anonymous giver was but I never eat a Mars bar without remembering God's providential care.

At the Centre, for twenty years or more, there had been a unique work initiated by Major Alice Sigsworth and Brigadier Eleanor Gebbie, for those who could neither hear nor speak. One lady, Bessie, who was a soldier at the Centre although unable to hear or speak amazingly could play a tambourine to music. Slowly I watched as she enjoyed the songs

using sign language. Eventually I learnt signage from Bessie and felt confident to use it in the meetings.

On one occasion, when one of the sensory-impaired group died, I was asked to 'sign' for the minister at the funeral. I took some of the deceased gentleman's friends in the car. All the passengers were communicating by 'signage' to each other and having a great 'conversation' but I couldn't join in as I was driving. This gave me a real insight into how people felt in the company of speaking and hearing people.

On Christmas Day, despite the builders, we managed to invite people along to the Centre for their lunch. The general public were so generous that we were able to buy each person attending a gift. The easiest way was to just buy in bulk and give everybody the same gift. One lady cried as she received her gift for it was the only one she had received. Needless to say, since then we have, carefully, tried to give each person an individual and suitable gift.

We ran a Luncheon Club for the elderly and soon became aware that two of the helpers didn't speak to each other. They had disagreed over some minor issue five years previously and wouldn't even speak to each other whilst at the Sunday meetings. After much prayer and many visits to both their homes they finally shook hands and agreed. Not long after this, the husband of one of them died. Because of the reconciliation the other lady was now able to help and share with her as a close friend.

A gentleman, whom we shall call Robert, moved out of a hostel into his own flat and started to attend the meetings and Luncheon Club. He was very dishevelled and dirty. As we visited him, we began to understand his situation as he had been brought up in a children's home, then transferred to a hostel. He had never had a home of his own so didn't know how to look after himself. The solution could have been to go in and clean the house through and supply him with clean clothes, but this didn't seem right. After all, it would have been like someone coming into our home and telling us how to live. We had to respect his privacy. One day he knelt at the Mercy Seat and asked God into his life and became a Christian. We took this opportunity of suggesting that now he was 'right' inside why not sort the outside out too. We went over every day and helped him work out a rota of what to do and gradually Robert learnt how to manage his home and his own appearance. It took quite a while but it was worth it.

It is traditional in The Salvation Army for musical sections to visit other centres and on one occasion, we had a weekend visit from Gosport Young People's Brass Band. On the Saturday we marched down the busy Mile End Road to where William Booth began the Salvation Army in 1865. There we held an open-air meeting. What a thrilling experience this was, not only for our own people, but for the visitors as well. Many of the people contacted came back to the Centre for the evening concert given by the band and our own young people.

Norma and I thought it would be therapeutic to take some of the children on holiday. We raised most of the finances by a sponsored 'Keep awake night' by the children but of course supervised by ourselves. This was plenty of fun despite being gruelling (8pm to 8am with 10 children to entertain!)

We took the children to The Blue Peter Log Cabin in the grounds of Sunbury Court in Sunbury on Thames. Although it was only 15 miles away from their homes, it was a different world, with trees and lawns and squirrels to feed, an outdoor swimming pool and acres of grounds to explore in safety. One shy youngster, an only child, came with us and it was wonderful to see her develop and inter-act with the other children. (Her mum said she was never the same girl after that holiday!) In the morning we developed a short Bible-based programme and each child had his/her own workbook to complete. Various activities, swimming, treasure hunts, games and even a campfire took up the rest of the days. We organised the children into teams for washing up and setting tables and a points system for clean and tidy beds and rooms. All these disciplines helped to run a happy and carefree holiday. The highlight of the week was a visit to a local theme park, where we spent the full day (10am -6pm). This gave the children plenty of time to enjoy the many rides. The younger children stayed under our supervision whilst the older children went in a group, reporting back each hour. Another highlight of the holiday was the last day when we went into Windsor. The

children were amazed as we watched a regimental parade from Windsor Castle, march down through the town. They didn't seem to mind missing the Queen, enough to see the Castle where she lived on occasions. This included a visit to McDonalds for lunch and then shopping for gifts to take home. The children returned full of stories of their exciting adventures, looking refreshed and relaxed which is more than could be said for us!

There were some sad occasions. I went to the local hospital with the mum of one of our guides, where her husband was seriously ill. The nurse took us into the corridor in the hospital to tell us that he had lung cancer and had only a few days to live. Appalled at the lack of sensitivity shown, I asked if we could go to a private room where mum could shed her tears in private. What did I say? Nothing. I just held her hand and cried with her and finished with a prayer for strength as we returned to tell her eleven-year-old daughter.

The four years in Bethnal Green were not easy, personally, especially as my mum died a year after my dad. Yet there was good support for us and God was able to use us. We anticipated our next official move being out of London and were surprised to find we were appointed to Notting Hill.

Chapter Seven

Our appointment to Notting Hill was quite a controversial one. Many of our colleague officers telephoned to say how unwise it was to send two single 'girls' into the situation there. This was mainly because of the work with the homeless people, some of whom had attacked our predecessors on a regular basis. However, we went to the appointment, fearful but knowing that God was with us just as He had been with us in all our previous appointments, especially Belfast.

There was an excellent feeding programme twice weekly. At lunch, a cooked meal was provided for the elderly and then in the early evening a cooked meal for the homeless people. This took up many hours of the week, in preparation, however friends and soldiers from the Centre helped us. We collected food from Marks & Spencer's which was at its sell by date and used this for many of the meals whilst also distributing food parcels to those families in need within the area. We certainly developed physical strengths we never knew we had as we packed the minibus full of food.

Each morning we prepared the lunches for the

elderly, served the food and had a little relaxed social meeting together. Afterwards, whilst the elderly people were taken home in the minibus, the homeless folk queued up at the side entrance. They were given a numbered cloakroom ticket when they paid their 20p for the meal on entrance to the Centre. This enabled us to serve on a first come first served basis at the serving hatch. We also introduced a printed Bible text for each person to receive, with a short comment about it before grace was said. The folk came to the serving area in multiples of five, which provided an opportunity to chat to them as they queued at the serving hatch for their meal. On one occasion, a gentleman was singing and I remarked on what a lovely voice he had. "Oh, yes, Major," he said " I've been in all the choirs: – Brixton, Pentonville, Wormwood Scrubs and numerous other prison choirs!" I had a good laugh with him over this but in talking to him after his meal I learnt that he had seventy convictions, mainly for being drunk and disorderly. He then shared how years previously he had been at work and his wife had gone out and left the children in on their own. The children had played with matches and both were burnt to death, but he did not blame his wife for his alcoholism. Behind so many of the homeless folk there was a story and it was very humbling when they trusted us enough to share them with us.

Because the meals programme was very time-consuming, we took our dog, Rex, to the hall on those days. In the mornings one of the pensioners

used to take him for a walk and in the afternoon one of the homeless men did the same. On one occasion, when Norma was taking the pensioners home in the minibus, she stopped at the traffic lights, looked around and saw the gentleman, with Rex, outside a public house. She looked again and was horrified to see Rex drinking a pint of beer. She jumped out of the minibus and said, "You can't do that. Rex is a Salvation Army dog!" (Salvationists pledge to be teetotal.) Poor Rex, he was so drunk he couldn't walk straight for three days! However we did let the gentleman take him for a walk again with the proviso – no beer.

People used to donate clothes, so we had cupboards built in the main hall, then at the end of the meal we could supply the homeless folk with decent clothing. Sometimes, because we relied on gifts from the public, we didn't have a coat or jacket to fit an individual and many a time, when I was apologizing, one of the others would offer his jacket saying, "Have this, I've got another at my place."

One regular visitor to the meals programme needed a suit because he was going to his nephew's wedding. He was fortunate because a suit his size had just been donated. We also had a shirt and tie to match and even shoes and socks. We arranged for him to come to the hall before the wedding, have a shower and shave and get changed. He certainly didn't look homeless after all this. In fact when he came after the weekend, still in his suit, he said he was the best-dressed person at the wedding!

On another occasion, I noticed a gentleman who

had no shoes on and had obviously been walking the streets of London in his socks. I asked him what size shoe he took, thinking we would be able to fit him up with some shoes. Apparently, he had been given a pair of size ten shoes but hadn't worn them for long; as he was a shoe size thirteen. Needless to say, we had none donated in that size. I told him to wait behind after the meal and clothing distribution and say nothing to anyone. In the meantime, I went out to a local shoe shop (after all the hall was in Portobello Road) and bought a pair of trainers and new socks for him. He and his mate did stay behind so I washed his feet and gave him his new socks and shoes. He was so pleased but said, "Could you do me one more favour?" "It's my mate's birthday today and he hasn't had a card." I quickly went to the office where I kept cards and wrote one for his mate. They were both so happy as they went out of the hall – one thanking me for helping his mate with shoes and the other for helping his mate out with a birthday card. The cynics perhaps thought he would go and sell the shoes for beer money, but he continued coming to the Centre and proudly showed me the shoes each time.

One of the men, who was an alcoholic, started attending our meetings. With the combined help of Alcoholics Anonymous and the fact that he became a Christian, he soon stopped drinking. He found it difficult as he mixed with the homeless for his meal, so we allowed him to come to the lunchtime meals. He had lost his home, his wife and his children because of the alcohol abuse. Eventually, through

The Salvation Army's Investigation Department, he was linked up with his wife and family. He was so proud as he showed us the photos of them all, and we even met his wife. It was wonderful to visit Notting Hill Goodwill Centre a few years later and find he was still sober and worshipping there. He shared his gratitude to God and The Salvation Army for caring for him. We were both moved to tears. It certainly made all those long hours worthwhile. The lines of a song we often used in the meetings sum up my thoughts: -

> Down in the human heart, crushed by the tempter,
> Feelings lie buried that grace can restore;
> Touched by a loving hand, wakened by kindness,
> Chords that were broken will vibrate once more.
> (Fanny Crosby)

The hall, being on the busy Portobello Road, meant we could arrange a Jumble Sale every Friday. There we provided tea and coffee and an opportunity to chat as well as pick up a bargain. In addition to helping with the finances of the Centre it was a real opportunity to get to know people. Some of the folk started to come to Sunday meetings. One young lady, married to a gentleman from the Middle East, asked if we could help her find a spiritual home. Needless to say, we introduced her to our meetings and when she had a baby it was such a joy to dedicate her little girl to God. (The Salvation Army's equivalent to a Christening.) She still keeps in touch although the little baby is now eighteen years old!

At the onset of the appointment we had been asked to develop children's work. Some people had reservations, thinking it was unwise to ask children into a hall that was associated with the homeless. Of course, the two groups never mixed and soon we had a busy Sunday School and many of the youngsters became Christians. We commenced a singing group, despite the fact that I am not a singer! But God had all this in hand. A lady in her thirties came one Friday and shared how she had been singing in a local production of 'Guys and Dolls', which features The Salvation Army. This had been the first time she had had any contact with the army, so she decided to come along and see what it was really all about. After attending the services regularly, she became a Christian. She had an eating disorder, but soon found God helped her conquer this problem. In no time at all, she was leading the singing group, which became a great deal more tuneful than when I had led it!

The children who attended the Sunday School were from all walks of life, many from broken families. On one occasion when the children were taking part in the service, there were five children with three different mothers but the same father! Four of the children lived with their dad and girlfriend. One year, on Boxing Day, we had a phone call from the second eldest child, with a plea for help. Dad and girlfriend, both under the influence of drink and drugs, were attacking each other. The eldest child, aged thirteen had gone for the police but the eleven year old had been detailed to find all evidence of

drugs in the home and hide them somewhere before the police came. By the time we got to the home she had taken them to a neighbour and as the police arrived to take control of the adults we stayed with the children until Grandma could be found to look after them. The following Sunday, the eldest child shared in the meeting all that had happened, including the assessment of the children's living accommodation. Her final words were "Where would we all be without God and The Salvation Army?"

One very icy evening I was putting the rubbish out at the front of the hall and on the way back slipped and broke my ankle. I shouted to Norma who immediately phoned the ambulance. However it was twenty minutes before it came and I was getting very cold. We didn't have any blankets in store, so Norma got some coats out of the men's cupboard and wrapped them around me. During this time the local Roman Catholic priest walked by, looked and then came back for a second look, asking 'Is that you Pat? I thought it was one of the homeless men!' It made me laugh even though I was in pain.

We had a good working relationship with the local hospital, mainly due to one of the soldiers of the Centre who visited the wards every Sunday afternoon. On one occasion he met a gentleman who had been a soldier at a corps which had closed. He still saw himself as a Salvationist even though somehow he had never linked up with another corps. We went to visit him each week and soon he

began to trust us. He was worried about the money in his home, especially as it seemed that Social Services were going to send in 'the clean up squad'. He gave us the key to his home and when we went in we were amazed at how many dozens of used batteries were in his living room. He had been so lonely since his wife had died and listened continually to the radio – his only companion. In the midst of all the chaos were his Bible, his wife's songbook and a picture of William Booth, the Founder of The Salvation Army. We marked all the things we felt he would want to keep and then went to find the money. When we opened the wardrobe, out fell hundreds of coins amounting to over £500 as well as £1500 in notes stowed in other places. We counted it all and then took it all to the bank. No wonder he was anxious about the money. The hospital notified us that his home had been cleaned and, as we couldn't be there, assured us that a Social Worker would be there when he was discharged from hospital. We were travelling back from Derbyshire on that very day. As we arrived home, I had this strong feeling that we should go round to his home and check he was all right. Imagine our dismay, when we found him sitting on a hard chair with everything else just left piled up as 'the clean up squad' had left it. He had been to the shop, but couldn't find a glass or cup to drink out of so he had used a vase! His bed wasn't made and obviously no Social Worker had been near to his home. How glad we were to get things tidied up and not least make his bed ready for use. We followed

this situation up with a visit to the hospital department responsible for discharging him and put in a complaint in writing. Thankfully, as a result of this, there was a new procedure introduced to make sure such an incident would never happen again.

Christmas Day throughout our appointment was always busy, providing lunch and tea for all those on their own. We had many helpers who came from all walks of life. A retired Naval Commander and his wife, Charles and Jean Wylie, from Fareham, Hampshire, came to help because during the war he had received a rock bun and cup of tea after a hard sea battle. They also were kept busy on Boxing Day, as they took all the food left over and distributed it to the homeless by the River Thames.

On the other end of the social scale, we had help from some of the homeless men. Many had worked in the catering trade and so on Christmas Day they walked over early, had showers and changed into clean clothes and then helped through the day.

One year we had dreadful weather, but still they walked over in the rain from Waterloo Bridge where they 'lived'. At the end of the day, we insisted we take them 'home' as it was still raining. When we arrived there, they invited us to see their 'home'. It was so moving to see how under the concrete walkways of the South Bank, they had a ledge where they had their sleeping bags, and decorations and cards displayed. This was particularly challenging to me as two days earlier the builders had moved out of our home, leaving bare plaster on the walls. This was after five weeks upheaval whilst a damp

course was inserted in the walls. During this period Norma and I had slept in the Centre and all this whilst maintaining our daily programme. I had complained bitterly asking "What sort of Christmas is this with no carpets, no wallpaper? It's awful". When we returned from seeing where the men lived, I was very humbled because at least I had a proper home, a comfortable bed and warmth. Another lesson to learn to appreciate what I had, not complain about what I didn't have.

One lady who came to the lunches couldn't get her husband to come along, since he had had a heart attack and had become a recluse. After visiting, we invited them both to the Christmas Day activities. They came and he so enjoyed the day that he started to come to the weekday lunches with his wife. They both started to come to the Sunday meetings. Eventually both became Christians and in time Senior Soldiers. God gave the husband a wonderful gift of writing poetry and for every occasion he would write a poem, sometimes funny, sometimes thought provoking. These poems certainly added a new dimension to our services.

There are so many memories from the eight years we were at Notting Hill. When we came to leave so many people were kind to us, giving us gifts – none more so than our homeless men who gave Norma a potpourri teddy bear and me a small silver frame, both appropriate to our tastes. They assured us they had bought them and not stolen them! We would have missed so many wonderful experiences if we had refused to go to Notting Hill.

How thankful I am to God for the rich tapestry of my life there. Our next appointment to North Yorkshire was definitely God's choice, but more of that in the next chapter.

Chapter Eight

Whilst still at Notting Hill, I had to visit Divisional Headquarters in Acton which was an old corps hall surrounded by flats and houses. God really spoke to me and told me He had a new work for me to do in pioneering work for The Salvation Army in a place where the Army had once been active. I shared this calling with Norma who said she too had felt God was calling her to do a similar work.

We wrote to the Army authorities and, after a while, the Divisional Commander who had worked with us in Belfast contacted us. He wanted us to go and re-commence Army work in the centre of Manchester. So as the Army's wheels began to turn we prepared ourselves for a move to inner city Manchester. But God had other ideas.

In late August, Norma, who was a very down to earth person, had a dream. In it I had decided we must go and sit in a certain field where there was one sheep. Deciding to move a little closer to the middle we were joined by another sheep. After a while we walked into the middle of the field and were surrounded by sheep and cattle. We then fell asleep, finding when we awoke that all the animals

had turned into people singing and praising God. We went into a flat roofed hut but it wasn't big enough to hold everyone. We walked past some water, a harbour wall, and then walked halfway up some steps, which had something at the top, we did not know what it was. We looked down and saw a building, which stood out, amongst the houses. "That's the place"

I said, pointing to it. We went back down the cobbled streets until we came to a derelict building. We gained the owners' permission to use it and, cleaning it up, found an army drum, a cornet and a trombone in a cupboard under the platform. We then realised that the Army must have used this in the past as this was the usual design of army halls. After we had opened the hall as an Army centre, the first person to enter it was an elderly lady in uniform. She thanked God for answering her prayers and gave us her offerings covering the past thirty years. Another lady came in, also saying that she had been praying for the Army to recommence their work in the town and asked how it had happened. We told her that it was a long story and asked if she knew where we were.

Norma shared the dream with me, saying she thought that place might be Whitby, but she had only been there once. I had been to the town for holidays with my parents and from her description I recognised it as Whitby. We didn't know if the Army was still in Whitby and so, wanting to know about the Army's link with the town, we contacted Major Jenty Fairbank at the Army's Heritage

Centre. She told us that the Army in Whitby had closed in 1946, the year I was born! She sent us a programme of Whitby's Corps Anniversary in 1932. In it was stated that the meetings used to be held in the old town hall, and whilst the services were held upstairs, sheep and cattle were being sold underneath!

We received information from the Tourist Board at Whitby, including a town map and a list of Churches. We marked out the list of Churches on the map and realised that there were two housing estates without a Christian expression and that one of them could be seen from the 199 steps leading up to St. Mary's Church and the Abbey.

As if to confirm these findings, Norma had a second dream about Whitby on 20th September 1991. The location was the same, but this time more detailed. In the dream, after parking the car we walked through the narrow cobbled streets. At one point a fence restricted us across the road, but we easily stepped over it. We then negotiated two more fences, which were progressively getting higher. But a fourth fence was so high that it was impossible for us to climb over it. There was a pile of house bricks nearby and , using the bricks as steps, we managed to get over the fence. We walked further on to the steps of the previous dream and there were no more obstacles. When we decided to return home the fences had disappeared. Norma woke with the shock!

During our private devotions we received further confirmations from God that all we had been expe-

riencing, though puzzling, was within His plan for us. We were constantly assured of God's presence and purpose through such Bible verses as:-

'There is still a vision for the appointed time; it will testify to the destined hour and will not prove false. Though it delays, wait for it, for it will surely come before too long.'
(Habbakuk 2:3 *REB*)
'Take heart ... begin the work, for I am with you, says the Lord of Hosts.'
(Haggai 2:4 *REB*)

Norma then had a third dream on 7th October 1991. We were back on the steps overlooking the houses and we had with us all the information we had acquired about Whitby, including the maps. I felt we should turn to The Bible, and said we should look in Isaiah 58:11–12.. Now I love my Bible as God's Word but don't know it that well. Norma woke up and shared the dream with me and together we read:

The Lord will be your Guide continually and satisfy your needs in the bare desert; He will give you strength of limb; you will be like a well-watered garden, like a spring whose waters never fail. Buildings long in ruins will be restored by your own kindred and you will build on ancient foundations; you will be called the rebuilder of broken walls, the restorer of houses in ruins.
(*REB*)

At the end of October we attended officer's councils at Swanwick, Derbyshire and as we were half way to Whitby we decided to visit 'The Promised Land!' One of the leaders at the councils said from the platform "If you have a vision, follow it!" At this stage only Norma and I and one other friend knew of the dreams, but we knew them to be real and definitely prompted by the Holy Spirit. We prayed that God would give us direct confirmation from at least one person as we went to Whitby. In fact, we were inundated with confirmations as, in uniform, we walked around the town ...

"Don't tell me the Army is at last coming to this God-forsaken place"

"I used to go to the Army, until I moved here."

"We need the work peculiar to the Army."

Others assured us that they would pray for us as we presented this unique appointing to the Army for consideration. In December, having written all the details of the dreams, we met the Army leaders and shared God's leadings.

By May 1992, contrary to the usual procedure of being told our appointment, we were appointed to Whitby! A credit to the openness of our leaders in recognising this was something bigger than anything we could have thought of. We even had the original Whitby Corps flag – another sign of God's amazing forward planning. A cadet working with us at Notting Hill told her father about the dreams and as he collected Army memorabilia he just 'happened' to have the flag in his possession, having acquired it twenty years previously!

For the first two Sundays we worshipped with Scarborough and Guisborough Corps as we were living in a flat in Scarborough and held our own 'meeting' at the steps where it all began. We wanted to consolidate God's direction and plans. We shared prayer, readings from The Bible and even a couple of songs, read rather than sung.

On the third Sunday, Guisborough were already booked for open-air meetings in Whitby and we joined them, actually conducting the open-air meeting on the East side. The greatest thrill was to carry the original Whitby flag through the streets for the first time in over forty years. This was particularly poignant when we actually marched over to the East side of Whitby as we had stood on every street corner during the week and prayed for the people. When we came to the bridge linking the main area of Whitby with the east side of Whitby the traffic lights suddenly 'stuck on

Red.' I stood there with the flag and prayed that the Devil would not get the victory over any battle that would take place then and in the future. The lights 'stayed red', but we marched into East Whitby with a positive and rousing tune from the band. The local paper covered the event and finalised the report with the words: "The future looks good for the Army in Whitby."

Although these open air meetings were exciting, we did feel we were not on the whole meeting the local people of East Whitby and so we commenced open air meetings on St. Peter's Road right in the centre of a council estate on the East-side. There

were eleven people at our first meeting: 2 Salvationists from Guisborough, 3 Methodists, 1 New Life Pentecostal, three Christian Fellowship members and Norma and me.

Each of the Christian friends, whom we had met over the weeks, told of their Christian experience and how they really had a burning desire to reach out to the local people. Our accompaniment? Norma playing her guitar. Later we bought a speaker system with the generous backing of people who also had caught the vision. The reactions of those participating varied from 'we've never seen anything like this sort of response, people standing at their doorsteps and even joining in the singing' to 'it's just like the old Army, meeting the real people who want to hear about Jesus'. We remembered with thankful hearts the prayer made by Colonel Ray Holdstock at our first interview: 'that the people of Whitby would receive us as prophets of old.' How God had honoured that prayer. Throughout the months of August and September we continued to hold open-air meetings at the same spot and travel each day from Scarborough to meet the people contacted and to prayer-walk the estate. After a visit of some teenagers from the Division, we even had an open-air Sunday School on a regular basis.

By nature I am a pessimist, but thankfully God is continually working on me to become an optimist. One day, I was complaining to Norma that we were at half measure. No hall to hold meetings, and no house to live in in Whitby. The Army do provide

accommodation for their officers but the only accommodation available in this unique appointment was in Scarborough. The following morning I read:

> 'Consider from this day onwards, from this twenty-fourth day of the ninth month on this day I shall bless you in full.'
>
> (Haggai 2:18,19)

We took this date as 24th September and claimed the promise. During the next week as we were prayer-walking the estate we saw a house had been put up for sale. God told us that was going to be where we lived, right amongst the people. We saw our Divisional Commander, Major Shaw Clifton and shared the experience. He put proposals forward to National Headquarters. In the meantime we viewed two halls in the area, one a children's play centre and the other a community centre. Directed by God we applied for the use of the community centre and awaited word. On 24th September that same year we had a letter from the council giving us permission to use the centre on a Sunday. We phoned Major Clifton and he said, "God has really kept His promise, because I have on my desk a letter advising we go ahead with the purchase of the house." What an amazing God! We called the house 'Ebenezer' which means 'hitherto hath the Lord helped us.'(1 Samuel 7:12)

In order to meet people of the town we commenced selling the Army's weekly paper *The*

War Cry at two spots in the town. Folk soon got used to seeing us there and over the months we listened to their problems and promised prayer for them. This has become a vital ministry over the years when, come hail or shine, we have stood at the same spots.

Our first meeting was held at St. Peter's Court. The community centre was the venue for a combined service with the Church of England as they used the premises once a month for their service. Rev. Bruce Harrison accompanied the singing on the piano and shared a five-minute thought on giving thanks to God for our arrival in Whitby. There were sixteen people at this first meeting, including the Christian friends who had been helping us in our open-air meetings, people from the estate and two people who came for the Church of England service. This was the first time that the Church of England had combined services and Bruce was happy for us to take over every week as he felt that, as long as God's message was preached that was all that mattered. The ladies from the Church of England were so glad that there was now going to be a service in the Centre every week. Our first indoor Sunday School followed this with sixteen children. During the next few weeks we commenced a Home League (women's meeting). The family fellowship began to grow and we were delighted when we were able to place the army flag in the Centre. A focal point of Salvation Army premises is the mercy seat and we had brought in our luggage from Notting Hill an old one that was

not used there. However, the problem was that it was in our luggage, which was still in Scarborough, so there was nothing else we could do but tie it on the roof rack of the car and travel the twenty-one miles over the moors with it! What a thrill when, soon after its placing in the centre, people started to use it in the meetings as a place of prayer.

By November we had moved into 'Ebenezer' and started to use it for tambourine and singing practices for the children, as we were not allowed to use the centre during the week, except for the Thursday Home League.

At the beginning of December we opened the house up for an all day of prayer and fasting. People were invited to come on the hour and leave by quarter to the hour. Many stayed for more than one section. We prayed for each of the homes within the estate and also for the newer housing estate across the main road. We prayed for the local schools, the Army's future in Whitby, all those who attended the Centre, both young and old, for the ministry of selling *The War Cry* and finally we prayed and consolidated directions given to us through the day. Each hour was commenced with an appropriate Bible reading and the singing of the chorus: '

Teach me how to love Thee,
Teach me how to pray,
Teach me how to serve Thee
Better day by day.

The Christmas period soon came and we approached the local Social Services to tell them, that despite a small kitchen in the centre, we were happy to provide a lunch and tea for those who were on their own on Christmas Day. With our previous experiences we knew it was needed. However the social worker was very negative and said this service was not needed in a small town like Whitby and anyway no one would want to use their cars to bring the folk, as it was a day to relax and drink! Despite this attitude, we still felt there was a need and as we talked to the people in the town it was apparent that it would be welcomed and supported financially. The editor of the local newspaper, who had two daughters who had been in The Salvation Army before moving to Whitby, supported us and helped formulate a letter for the paper, inviting people to come, requesting financial help and drivers. What a thrill when thirty people came for Christmas Day, brought by five different volunteer drivers and we were covered financially.

On the first Sunday in the new year we introduced a prayer list when all those who worshipped on a Sunday, wishing to commit themselves to praying for each other, were invited to take a prayer list at the closing moments of the meeting. We were thrilled when all present reverently came forward and took on this commitment.

The work continued to expand, as the young people became Christians and were trained as Junior Soldiers. They, in turn, brought their mums to the Army and to know Jesus. So others became

senior soldiers too, including Bob Armer, who lived with his wife Rene, next door to 'Ebenezer'. They had applied for a council exchange in Banbury but had had no replies until Bob decided to become a soldier, and Rene an adherent. Once these decisions were made there followed three offers of exchange, but it was too late because they both recognised it was God's plan for them to stay and worship at the Army in Whitby. Bob, on becoming a senior soldier, commenced visiting housebound people whom we had contacted through the open-air ministry and also he began to visit a local residential home for the elderly. This was an added challenge for Bob because of his speech impediment, but he knew it was God's will and he continues in this valuable ministry to this day.

When Joan and Victor Scher settled in Whitby they were sorry to find there was no Army to link up with. Joan had been an adherent at another corps where Victor had attended the meetings with her. When the Army came back to Whitby, they gave their full support, Joan was re-enrolled as an adherent and later Victor made the same commitment. They were really kind to us, opening up their home on numerous occasions as a base in Whitby and as a haven.

The years passed by and more activities commenced. This included a young people's brass band, which played carols on the streets of Whitby for the first time for over forty years. Luncheon Club preceded The Home League and of course Christmas Day meals were provided even though it

meant cooking half the meal at the Centre and the other half at our living quarters. Fortunately it was only a two-minute car ride to collect the steaming hot vegetables when they were required. We had good volunteers for the Christmas period, which also included distributing toys and food parcels for those in need. A local school was a great help in providing information about those in need. One family we went to, mum was an alcoholic, but loved her three children. They didn't know we were coming with toys and food and even a Christmas cake. The ten year-old boy on seeing us said, "See Mammy, I knew Jesus would answer our prayers." We left their home, so glad that we had been directed there and that God was going to make their Christmas a very happy one.

Whitby is quite an isolated spot, twenty-one miles from all major towns. We felt it would be a good experience to take the young people for a holiday to the Army's Blue Peter Log Cabin in Sunbury on Thames. None of the youngsters had ever been to London so it was a real adventure for them. We kept the format similar to the other holidays we had had there and the youngsters were thrilled to see the sights of London, especially Buckingham Palace and 'The Changing of the Guard'

For one youngster the highlight of the week seemed to be me rescuing the girl's dormitory from a spider with a squirt of fly spray. (I have a distinct fear of moving spiders!) The youngster wrote to the Army's paper *Kids Alive*, telling them of all the fun they had had and saying what a brave Major I was

to kill the spider! She was awarded a star letter prize and she was so pleased. A few weeks later I received a letter, which had been sent to the Editor of *Kids Alive*, remonstrating with them for rewarding a child for a letter about killing a spider. With it was a personal letter to me saying how disgusted she was that I had killed one of God's creatures!

Life was hectic with young people and adults using the quarters every day and every evening. I guess something had to give and after speaking at a Women's World Day of Prayer I realised something was wrong with me. The doctor diagnosed 'burn-out' and said it was not a good idea to have work in the home all the time. But what else could we do? The council wouldn't let us use the Centre any other day but Sunday and Thursday and there was such a need. Good came out of a bad time, for after approaching the council again with the added argument of my health, we were allowed to use the centre for two more days, even if it did mean getting it in order after the Bingo sessions held there.

Right from the onset we had tremendous support from most of the other Churches in Whitby and joined with them to enter a float in the Whitby Regatta parade, held in August every year. The loaned lorry was fitted with a lighthouse and on the sides words were painted 'Jesus light of the world' Representatives from each church sat on the float and distributed sweets and tracts to passersby. The float was awarded second prize but what was more important was that the churches of Whitby were seen to be working together. In successive years

open-air meetings were held with capacity crowds looking on and listening to testimonies from Whitby people whose lives God had changed.

Then came the bombshell! Norma was diagnosed with breast cancer and had to have a mastectomy. It was so difficult to keep the entire work going and at the same time to care for Norma and be optimistic. The people of the centre were wonderful and so supportive, not only with prayers but also practically, often cooking us a meal or washing and ironing for us. Our prayer supporters around the country were made aware of the circumstances and we really valued their prayers. Norma's faith was really challenged at this time as we were both reminded of our frailties. However, Norma did recover and we were soon back working together as a team.

Our annual prayer day was held each year when God brought new ideas and plans to develop. These included an Easter Campaign week and a Pentecostal Retreat. Some folk left the family but others joined and the family was still growing and we always gave God the glory for every wonderful experience.

It was not so easy to give God the glory when Norma was taken ill again in 1998. We didn't realise how serious things were, but Norma continued to lose weight and became very breathless. We went on holiday to Craster, Northumbria for two weeks. The first week Norma seemed okay, but the second week she was really poorly, staying in the flat for most of the time. I went on walks and took

lots of photographs to show her when I got them developed. But, it wasn't to be. On our return to Whitby Dr. Newman, who had been so supportive to us both, came and on the Thursday Norma was taken to Hull Hospital for further tests. Mavis, Norma's sister, came for a planned holiday on the Friday evening and so visited Norma in hospital on the Saturday. I couldn't go because I had to lead band practice for the Regatta open-air meeting on the Monday. Mavis left her mobile phone with me so she could contact me and tell me how Norma was. The phone rang, but not being technically minded, I pressed the wrong buttons! I phoned the hospital ward and explained what had happened and then was told that Norma had died peacefully in her chair, even before Mavis had got to the hospital. Fortunately, I was with our Corps Secretary Christine Pennock who had become a Christian through her daughter's witness, and after notifying Divisional Headquarters I said that I wanted to go to all the homes of the people of the Centre to tell them the news as I didn't want them to experience what I had by receiving the news over the telephone. Chris said "You and Norma always prayed about everything so I'm going to pray for you now and then come with you." This support was a great help as we prayed in over twenty-five homes having shared the news of Norma's death. We were a family grieving together. By the time we arrived back at 'Ebenezer' Lieutenant Colonel Ray Kirby, the Divisional Commander for our area, was there and offered practical and spiritual support through-

out that and successive days leading to Norma's funeral. What an experience that was! The funeral was held in the chapel of Sneaton Castle, run by an Order of the Church of England Sisters of the Holy Paraclete. Norma and I had often discussed what we wanted at our funerals, not morbidly, but rationally so the funeral planned by the Divisional Commander was made so much easier. There was a brass band made up of officers of the Northern Division of The Salvation Army and family, friends and colleagues joined with the people of the centre and those of the town to celebrate Norma's life. To say it was a happy occasion may seem strange but there was lots of clapping and laughing and positive singing of songs such as: -

'When we all get to Heaven,
What a day of rejoicing that will be!
When we all see Jesus,
We'll sing and shout the victory!'
And
'Yes, we'll gather at the river,
The beautiful, the beautiful river,
Gather with the saints at the river
That flows by the throne of God.'

The Headmaster of the local school, who had worked with us on numerous occasions, including Christmas days, spoke of his memory of us first coming to Whitby and how right it was that we lived in the housing estate of those we were working for. He finalised this by saying "God never makes a mistake!" The sisters of the chapel were really kind

and one special touch was the ringing of the chapel
bell for Norma's fifty years of life; something they
did for their own sisters.

The following two and half years were years of
adjustment. How hard it was to help those of our
centre family who were grieving whilst I too was
grieving. I had tremendous support from officers
and friends, from the sisters of the chapel and our
doctor. One thing that puzzled me was why God
had not kept the promise from Isaiah:

'The Lord will give you strength of limb; you will
be like a well-watered garden, like a spring whose
waters never fail. Buildings long in ruins will be
restored by your own kindred and you will build on
ancient foundations; you will be called the rebuilder
of broken walls, the restorer of houses in ruins.'

I shared these doubts with no one but God, as I
shouted and 'beat at His door' in prayer. How
patient God was to me, how loving, even if I didn't
feel it. Gradually and gently God led me back to
that promise again and very gently pointed out that
the promise given was in the singular, not the
plural. So by His help I began to pick up the pieces
of my frail and feeble faith. I missed Norma's opti-
mistic outlook on life, her laughter and yes, even
her cooking. She had always done the cooking for
twenty-seven years. My whole life was changed and
amidst all this I had to care for a hurting, grieving
congregation. God was so good to me, giving many
kind people who listened to the tears and question-
ings and stood by me through it all. The weekends
were the loneliest and hardest and so Chris and her

husband Dave opened their home to me and every weekend I stayed with them and had my meals there.

As time went by, I began to emerge from my grief and often went to St Oswald's; a retreat centre three miles from Whitby, run by the Order of the Holy Paraclete. During one of my stays there, one of the sisters suggested I might find it helpful to visit a retreat centre known as 'The Society of Mary and Martha'. It was organised by the Church of England and was especially for ministers of every denomination. I went in April, my first venture on my own without Norma (we had always holidayed together). I came back from that week energised and with much of my grief lifted. I was ready to pick up the pieces and get on with the ministry of being an officer. But less than a month later I was diagnosed with breast cancer and had a lumpectomy. It was hard visiting the same hospital and consultants that I had gone to with Norma and only God's gifts of good friends and family saw me through this period. Divisional Headquarters staff were excellent too, taking on the responsibility of looking after the Centre meetings. Looking back on this time I feel that this was a time for the people to grow stronger and own the Army and activities for themselves, for they certainly did work together to achieve great things. I had to go to radiotherapy treatment five times a week for five weeks to Middlesborough, thirty-three miles away. The people of Whitby were wonderful and when Chris contacted folk for transport, within ten minutes

drivers had been found and the five weeks were covered. One memory of this time was when Guisborough Band came and played outside the quarters. Included in the tunes was Penlan, which is the tune associated with the words:

'In heavenly love abiding,
No change my heart shall fear;
And safe is such confiding,
For nothing changes here.
The storm may roar without me,
My heart may low be laid;
But God is round about me,
And can I be dismayed?'

Having radiotherapy is not as bad as chemotherapy but the worst experience was when, encased in a plastic cast, screwed down to a table I was left alone whilst the rays were targeted on the cancerous area. After the first day I knew I had to find something to think about for those two single minutes. God, in my prayer time, gave me a verse from the Bible, which I memorised and went over and over in my mind during the time of the treatment. It became quite a topic of conversation with the drivers as they soon wanted to know what text God had given me each day.

When I eventually went back to work God gave me a renewed energy to tackle all that was needed to be done in the Centre. Although I hadn't wanted this interruption in my life, God did use it and the people of the Centre began to 'own' the work as their own. Soon after these events I, along with The

Divisional Commander and The Army's Property Secretary were summoned to the Council Offices to be told that it had been decided that the community centre we were using was to be knocked down and replaced by bungalows. Were we to lose this as well? Local councillors supported the Army and a petition of over 1000 signatures was taken to Scarborough Council. As a Christian family we decided to pray every day at twelve noon for a change in their decision and we linked this with a chorus:

> The steadfast love of the Lord never ceases,
> His mercies never come to an end,
> They are new every morning,
> New every morning.
> Great is Thy faithfulness, O Lord,
> Great is Thy faithfulness.

Thankfully, after many weeks of concern the Council relented and they then suggested that the Army lease the ground floor of the building from them whilst council tenants remained in the upstairs flat. The wheels ground very slowly but eventually the lease was signed and the Army found finances to have the twenty-five- year-old building renovated. This time proved very interesting as the programme continued as well as possible in a portakabin! We still had the proverbial 'Army cup of tea' at the Home League thanks to a hot water boiler and kind neighbours.

A month before Christmas the builders were still working on the kitchen but giving them no pressure!

I wrote to the local paper inviting people for a Salvation Army Christmas Day meal!

Divisional Headquarters provided the basic kitchen equipment, but we felt to function as a proper kitchen we needed a plumbed-in water boiler, and a Bain Marie to keep the food hot. The funds were dwindling but in faith I asked the Property Secretary to order the extra equipment feeling sure the money would come from somewhere! All the equipment arrived a week before Christmas Day and through the generosity of the local Whitby folk, so did the money to pay for it! Although the Centre refurbishments were not fully finished we did have our Christmas meal and for the first time were able to cook it all on the premises.

During the first months in the New Year we began to plan for an official opening of the refurbished building. The chairs didn't arrive until 8 pm the day before the opening but with lots of teamwork we managed to get all the wrappings off and the hall was set by 9 pm. On 3rd April 2004 the Centre was opened as The Salvation Army. We prayed as we sang

> Build Your Church, Lord,
> Make us strong, Lord,
> Join our hearts, Lord, through Your Son,
> Make us one, Lord, in Your body,
> In the Kingdom of Your Son.

It was such a thrill to see over eighty people squashed into the Centre and we rejoiced as we

sang our chorus: 'The steadfast love of the Lord never ceases.' At last there was an established 'Army' on the housing estate. My only sadness was that Norma wasn't there but I know her spirit was and, along with many others, she would be rejoicing in Heaven.

A renovated building attracted new people to the meetings and new ventures like a card-making class and a craft class meant different people were coming into the building. Through the kindness of Whitby Rotary Club we were able to purchase a dishwasher, a real asset for the luncheon club.

On 25th July 2004 the whole congregation were invited to take a bookmark to show their commitment to praying each day for new people to join the Christian family, in God's timing, and to His glory. Bookmarks were also sent to our prayer partners who had faithfully supported us through those early years, not only with prayer but financially too. Soon new children and adults began to attend the meetings and we rejoiced at this answer to prayer.

On the anniversary of this event in 2005 we again committed ourselves to prayer, adding that God would also send the right officer for the next year, bearing in mind that I was to retire. What a thrill when the following February we learnt that Captains Allen and Marie Bate were to be appointed to the Centre. At divisional officers' councils the theme was 'The still small voice of God'. I was very familiar with this passage of Scripture (1 Kings 19: 9-16) where God spoke to Elijah. We had time to look and ponder on the story as

individuals and God made it very clear that one of the tasks 'The still small voice' asked Elijah to undertake, was to pray with his successor, Elisha. Opportunity was given to move around the room and pray with other colleagues as the Spirit led and so it was a real privilege to share prayers with Allen and Marie.

Time was going by, and the Army had said I could look for a property wherever I wished to retire to. There was no other place I could imagine retiring to than Whitby. So the search began as the Army said they would purchase a bungalow. God had sent to the Centre, Eileen Moran, a lovely Christian lady, who had experience in property buying and selling and she was such a help to me. We viewed a few properties and Eileen phoned the estate agents to view a further property. That particular property had gone but another had just come to their notice that day, and it might prove suitable. We viewed the bungalow and I just knew it was where God wanted me to live. For a few stressful weeks things seemed to stand still, but eventually the deeds were signed and the Army purchased the property for me to rent. Then, of course, came the task of choosing and purchasing furniture with the considerable and generous grant given to me by the Army. I didn't want to waste the money and prayed for God's guidance every time we went to look for something, even to the wallpapers as the whole bungalow had had to be re-wired. I decided to call the house 'Bethany' because that was where Jesus went for a rest! In the meantime the current quarters had to be

cleaned; I had to pack and minimize fifteen years of accumulated possessions because I was going from a four bedroom house to a two bedroom bungalow. I was so grateful for the practical help given by Jean and Bill Gold, without whom I would have never managed. I got to know my neighbours even before I moved in and what a thrill to find right opposite were Jean and Ian Hobbs, two devout Christians, who prayed with me countless times before I actually moved into the bungalow. No wonder there is a real peace in the garden and the home when so many friends and family, sent by God, have helped me.

Another concern was that when I retired, I would have to return the company car

that the Army provides for its officers to undertake their ministry effectively. That would mean I would become quite isolated in Whitby (21 miles from the nearest towns) but God had all that in hand too. Remember Charles and Jean Wylie who came to help us in Notting Hill over the Christmas period? Well, they were visiting someone in Scarborough, so came over to see me. I must have mentioned my concern about the car situation but don't actually remember doing so. Imagine my surprise and gratitude when they wrote to say they wished to give me a car for my retirement! They brought it up from Fareham, taxed and insured , so I became the proud owner of a 1998 Hyundai Accent, which had only 24,000 miles on the clock. I was so humbled to think those eighteen years earlier when we had met Charles and Jean that God

had planned for my retirement. It certainly under-
lined the promise

'Even before they call to me I shall answer, and while
they are still speaking I shall respond'
(Isaiah 65: 24 *NEB*)

I'm so glad that the lady who gave the cup of tea to
Charles during the Second World War was faithful
in her service, which resulted in me having a car for
my retirement! Charles said, " You will never forget
the registration letters (KJF) because it is King Jesus
First." It is a constant reminder as I use the car that
Jesus must be first in my life.

How quickly Saturday 15th July 2006 came, the
date for my retirement service or, as it was entitled,
my 'Celebration of Ministry.' I will be forever grate-
ful to the Sisters of the Order of the Holy Paraclete
for allowing the use of their chapel at Sneaton
Castle. It was where we had held Norma's funeral
and it just seemed as if the retirement service ought
to be there. I expected there would be about a
hundred people there and was quite overwhelmed
when two hundred and fifty people gathered to
share the wonderful occasion. They were from all
walks of life within Whitby but also my own family
and friends including Jean and Charles.

I'd prayed that morning that God would give me
a calm mind and spirit so that I could remember
everything that was to happen that day and that
God would be glorified in it all. By my request,
Guisborough Band attended and played 'His

Guardian Care', a piece of music which had reminded me through the years that 'God was still on the throne.' Majors John and Teresa Carmichael sang a beautiful song ' He's more than wonderful' which reminded me of God's wonderful love to me all through the years. The young people from the Centre, at my request, mimed to the song 'Lord, Jesus here I stand' which included the words: -

'Lord, Jesus here I stand before You.
To worship and glorify Your name.
I humbly bow the knee before Your majesty,
Give You the glory,
Give You the praise.'

The Divisional Commanders Majors Melvin and Suzanne Fincham led the service and I chose the songs: 'God's love to me is wonderful' 'Great is Thy Faithfulness' and of course 'In Heavenly Love Abiding.' Major Melvin quoted from my sessional dedication song the words 'Turn these moments of faith into years of grace.' He didn't know how often through the years I had prayed that prayer but of course, God did.

Bob Armer, our neighbour, spoke as well as Major Melvin and I really felt they were speaking about someone else, as I just didn't realise how much God had used me and changed me over the years. It was a truly memorable day and God certainly answered my prayer of the morning. At night I shared a meal with my family and Amber, my great niece, recognised me as I wasn't in that funny suit (my uniform)!

On the Sunday we all shared as God's family at the Centre and my prayer was that we would all grasp even more than ever the length, breadth, height and depth of God's wonderful love.

When I look back over the past thirty-eight years of officership, I am amazed what God has done through me, despite me being me. I could never have imagined all that has happened, the places I have been and the experiences God has given me.

I am so grateful to all my friends and family who have supported me over the years, for being at the end of a phone when I reached my limits and for all the love and support given to me especially since Norma died.

As previously mentioned the song 'In Heavenly Love Abiding' has been with me all through my officership, ever since Covenant Day, but in these latter days, the final phrase of the song has become more meaningful 'My Saviour has my treasure and He will walk with me'. The emphasis has shifted from me walking with Him to God walking with me, a fact that daily I am aware of.

Whilst packing I came across a newspaper article about my dad who had to retire early through ill health and took up the hobby of making things out of wooden pegs. At the end of the article were these words: 'Mr Charlesworth is out to show that life can begin on retirement instead of coming to an end.' Joan Scher repeated this thought in a poem she had composed 'This is not the end but a new beginning'. God hasn't finished with me yet. He has

more awkward traits in me to refine so He can use me in His service in the future.

At the final officers' retreat when I first met Majors Allen and Marie, God had told me in my morning prayers that He wanted me to be an encourager by sending cards of prayerful support to the people He directed me to. On that same day someone said to me 'Pat, you're not going to stop when you retire, God has a special job for you as an encourager.' What a confirmation and how often I have received acknowledgement that the card just came at the right moment, God's moment.

I moved into 'Bethany' the following week and Majors Allen and Marie moved into the quarters. We all settled into our new roles, they as leaders, and me as a supporter. The work has continued to expand and develop under the leadership of Majors Allen and Marie, which was endorsed when two of the people from the Centre shared their initial misgivings about having new leaders and their thankfulness that God had answered our prayers by bringing the right officers to Whitby.

Before I retired God placed on my heart the setting up of a support group for bereaved people here in Whitby. He even gave me the name: 'The Empty Chair' After negotiations it seemed that I would have to pay £10 per session. Being on a pension, I thought it would be difficult to find that amount each month and talked to Allen about reducing my cartridge until The Empty Chair became established. In the meantime a friend who had designed our leaflet suggested she put to the

trustees of a local charity group that The Empty Chair should pay a reduced rent and use their facilities. Not only did this happen, but The Endeavour Rotary Club offered to cover all costs for a year! There were so many generous people that we opened in November 2007 with funds which have enabled us to take the clients to Durham for the day including one lady who had never gone anywhere since her bereavement. It has been encouraging that when a meeting was cancelled due to holidays etc. that the ladies met each other independently. So ' Bethany' may be a place of rest and peace but it doesn't mean stopping my service for God and His people.

The following verse seems to be a fitting conclusion to all my experiences: -

'Blessed be the Lord my God, His faithfulness to me has been constant and unfailing.'

Genesis 24: 27 (R.E.B.)